OCEAN

Ocean

Ocean

Oceans cover more than two-thirds of
the surface of the Earth. They support
an unbelievable amount of life, from the
plankton-rich waters of the Arctic and
Antarctic to coral reefs which can hold more
species than an equivalent area of rainforest.
Of course, this watery world is hidden from

the eyes of most humans, which perhaps explains why we choose to treat the planet's seas as a giant waste bin!

This book is a celebration of the world's ocean life. It covers creatures of the shores such as birds, seals and molluscs, together with fishes, squid, octopus, cetaceans and many more life forms which inhabit the shallows and the deeper seas. It depicts watercolour paintings and other artworks of ocean wildlife and marries them with quotes that cover everything from deep philosophical thoughts to comments that will make the reader laugh out loud.

"He who would learn to fly one day must first learn to stand and walk and run and climb and dance; one cannot fly into flying."

– FRIEDRICH NIETZSCHE

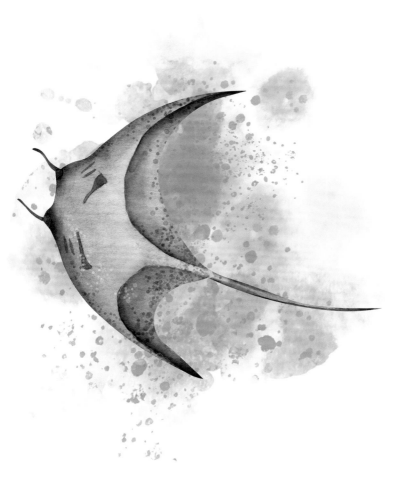

"I remain just one thing, and one thing only, and that is a clown. It places me on a far higher plane than any politician."

– CHARLIE CHAPLIN

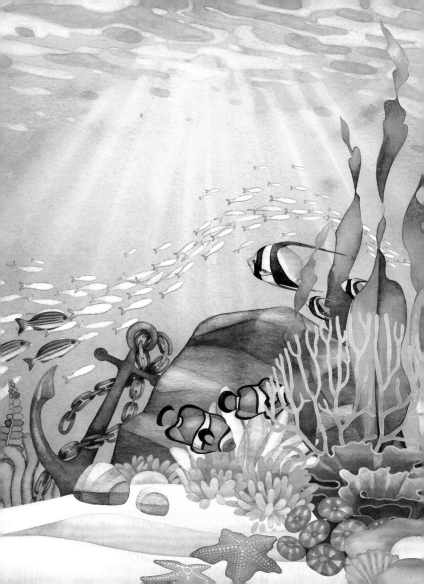

"You can lead a horse
to water, but a pencil
must be lead."

– STAN LAUREL

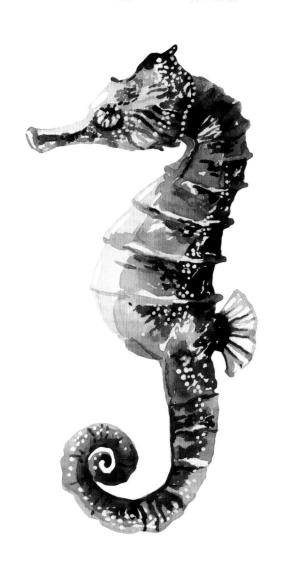

"I am impelled, not to squeak like a grateful and apologetic mouse, but to roar like a lion out of pride in my profession."

– JOHN STEINBECK

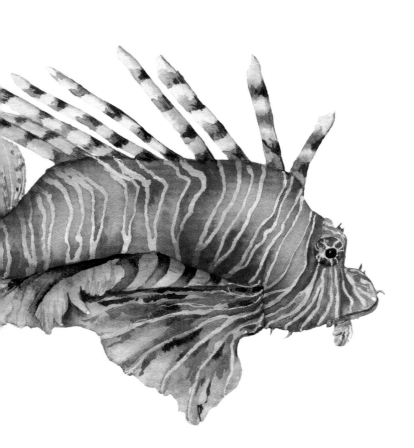

"I saw the angel
in the marble
and carved until
I set him free."

– MICHELANGELO

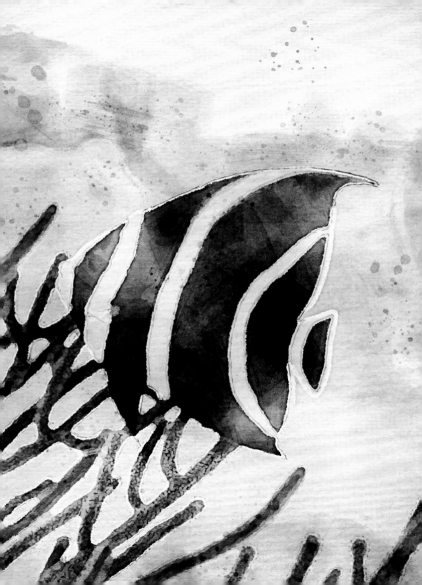

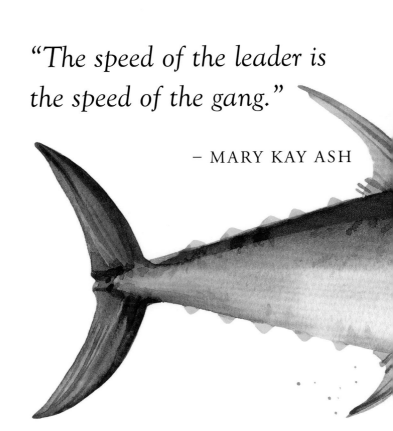

"*The speed of the leader is the speed of the gang.*"

– MARY KAY ASH

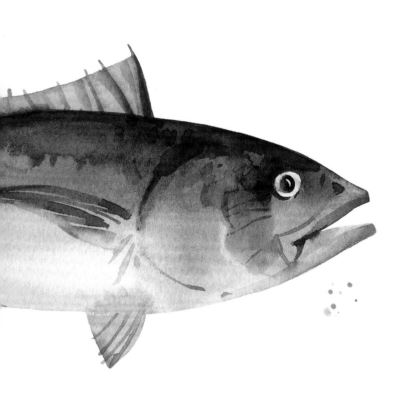

"*The only way to make sense out of change is to plunge into it, move with it, and join the dance.*"

– ALAN WATTS

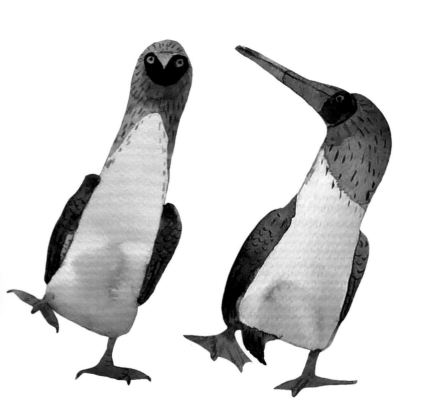

"Always remember that you are absolutely unique. Just like everyone else."

– MARGARET MEAD

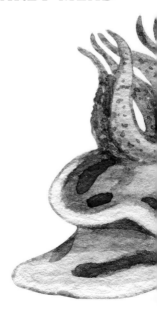

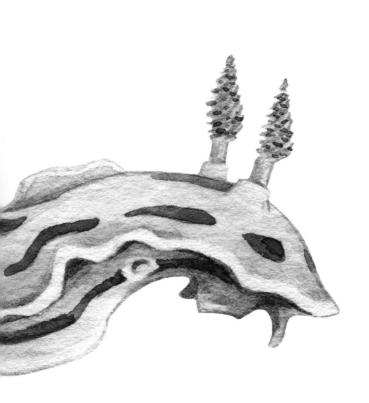

"One cannot collect
all the beautiful shells
on the beach."

– ANNE SPENCER

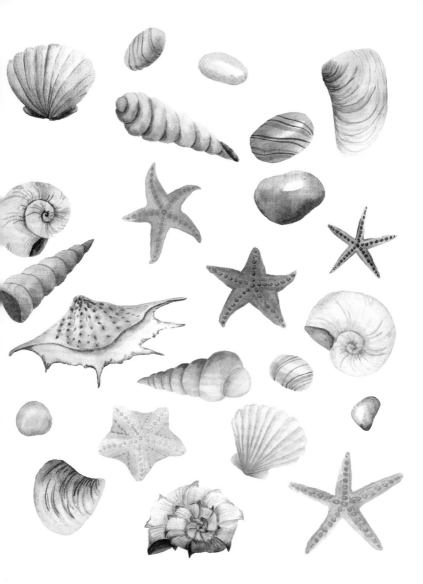

"*People need to look at wildlife conservation in its totality. As soon as you lose*

the apex predator, it has harmful consequences right down the food chain."

– THOMAS KAPLAN

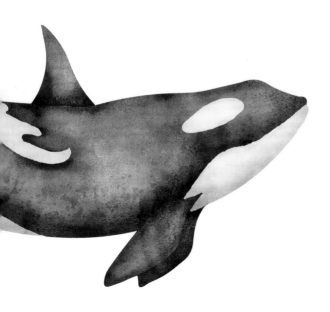

"*For small creatures
such as we
the vastness is bearable
only through love.*"

– CARL SAGAN

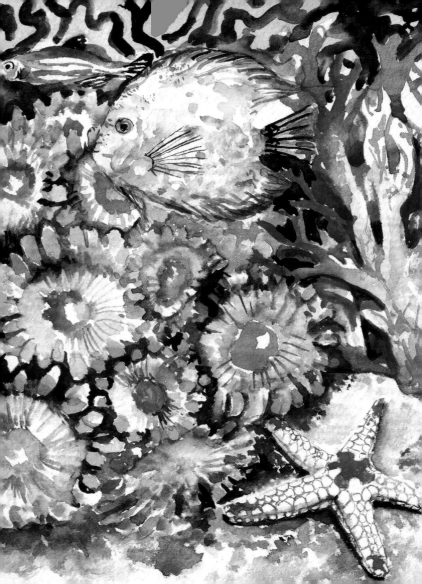

"Chance is always powerful. Let your hook always be cast; in the pool where you least expect it, there will be fish."

– OVID

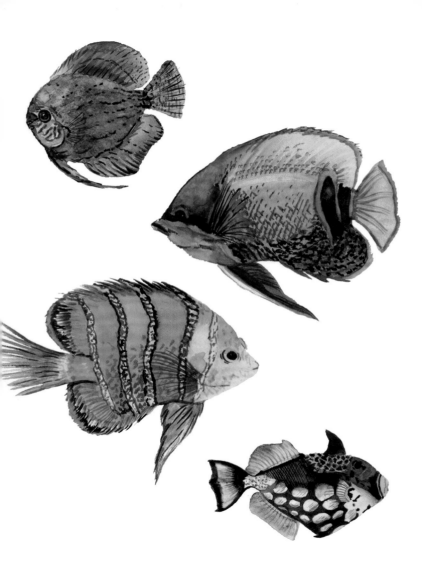

"*But for their cries,*
The herons would be lost
Amidst the morning snow."

– FUKUDA CHIYO-NI

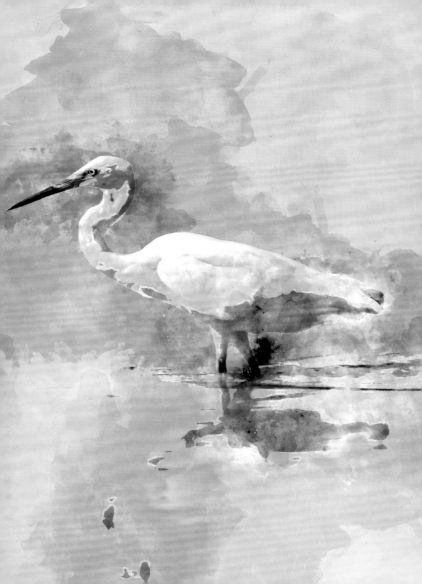

"People see me and they squeal like tropical birds or seals stranded on the beach."

– CARRIE FISHER

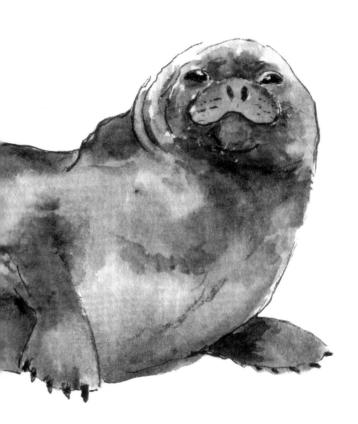

"*I wear my stripes on my sleeve, and I am not afraid to show them.*"

– ALUN WYN JONES

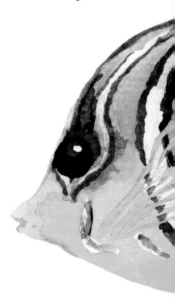

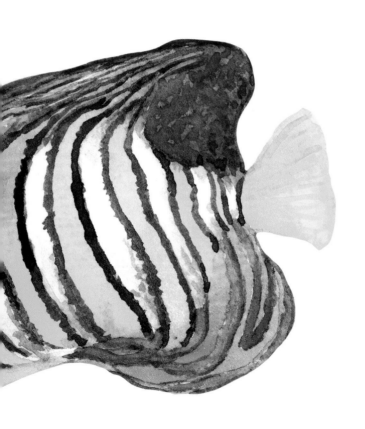

"Manatees are real, mermaids aren't. Rhinoceroses exist and sea monsters don't. There are no more sea serpents guarding deadly whirlpools. There are pirates, yes, but there is nothing romantic about them. The rest is all stories, and stories have been put in their place."

– JODI LYNN ANDERSON

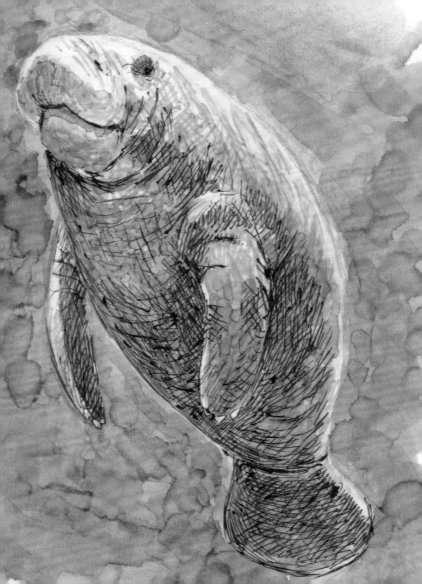

"*The only thing that makes sense is if the universe is beautiful and simple and elegant.*"

– ANTONY GARRETT LISI

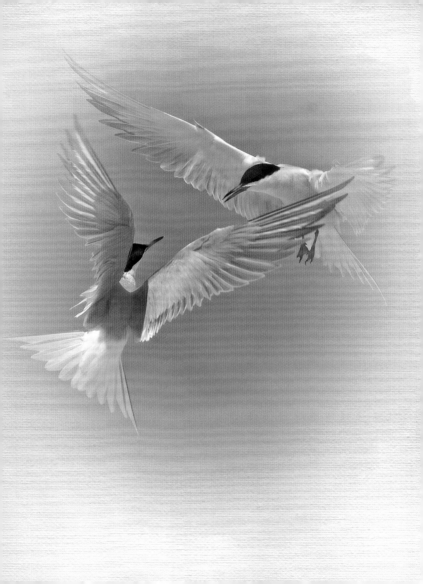

"I never saw a painting that would not be improved by the addition of tropical fish."

– JOHN COOPER CLARKE

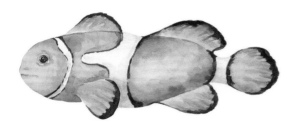

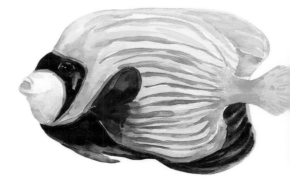

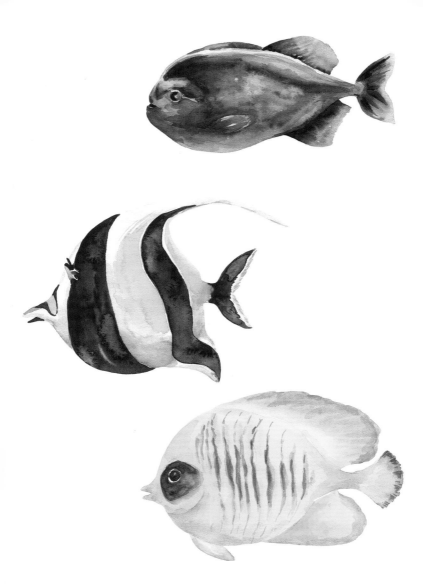

"*Don't force it,*
get a bigger hammer."

– ARTHUR BLOCH

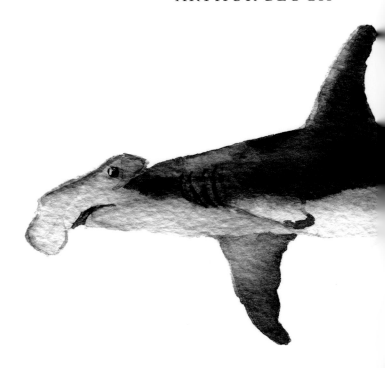

"*Porcupine, whom one must Handle, glove'd,*
May be Respected,
but is never Loved."

– ARTHUR GUITERMAN

"*Blue, green, grey, white,
or black; smooth, ruffled,
or mountainous;
that ocean is not silent.*"

– H. P. LOVECRAFT

"*I love puffins. They are small, round gothic birds, and their babies are called pufflings.*"

– CAITLIN MORAN

"*To escape and sit quietly on the beach – that's my idea of paradise.*"

– EMILIA WICKSTEAD

"*There's lots of good fish in the sea... maybe... but the vast masses seem to be mackerel or herring, and if you're not mackerel or herring yourself, you are likely to find very few good fish in the sea.*"

– D. H. LAWRENCE

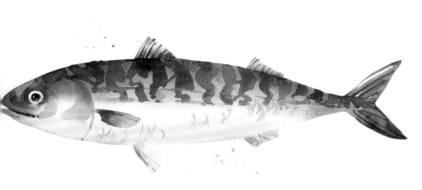

"It is of great use to the sailor to know the length of his line, though he cannot with it fathom all the depths of the ocean."

– JOHN LOCKE

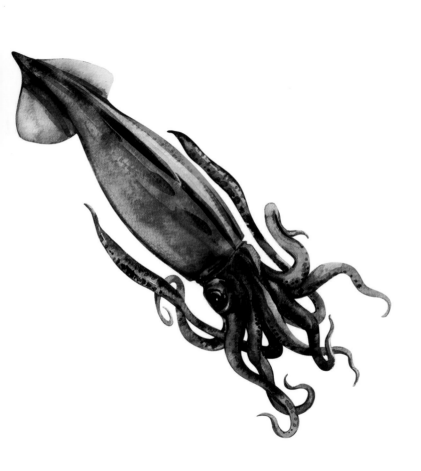

"Problems are only opportunities with thorns on them."

– HUGH MILLER

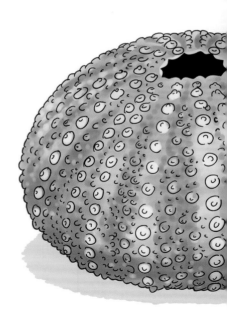

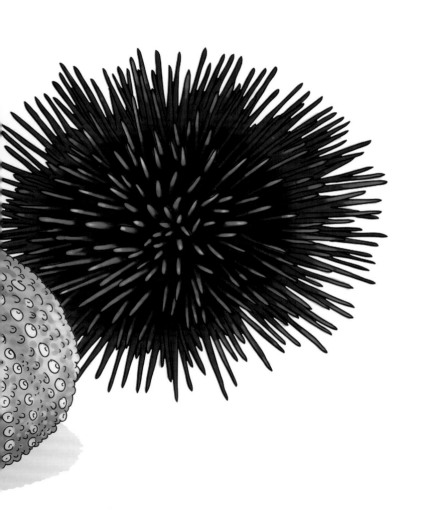

"Behold the turtle.
He makes progress only
when he sticks his neck out."

– JAMES BRYANT CONANT

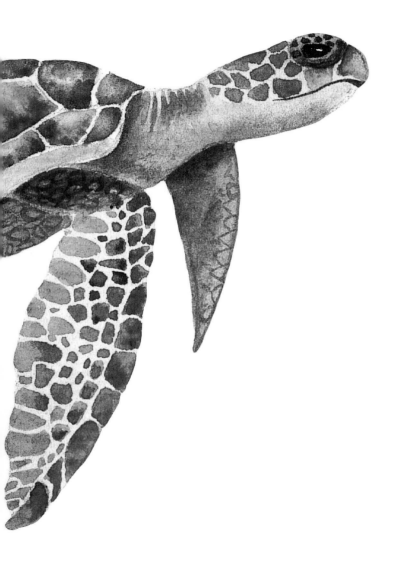

"I have wandered all my life,
and I have also travelled;
the difference between the two
being this, that we wander
for distraction, but we travel
for fulfilment."

– HILAIRE BELLOC

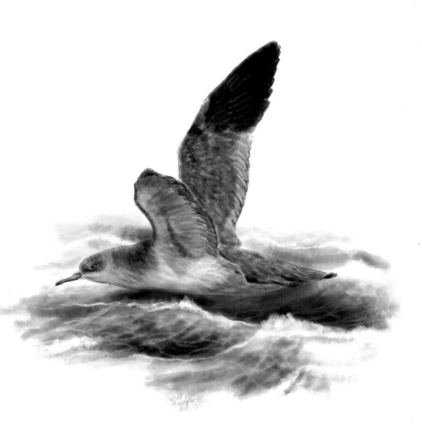

"You cannot teach a crab
to walk straight."

– ARISTOPHANES

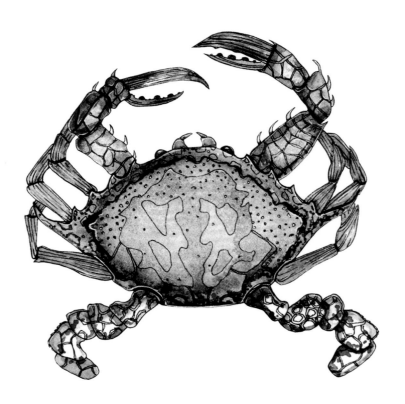

"I love to fish. You can go hours without anything happening, and all of a sudden a big blue marlin comes into the spread and it's cockpit chaos. My dream is to catch a grander, a 1,000 pounder."

– GEORGE STRAIT

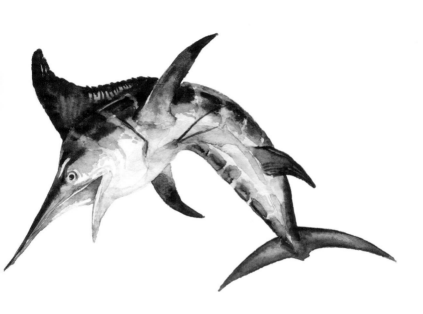

"A jellyfish is little more than a pulsating bell, a tassel of trailing tentacles and a single digestive opening through which it both eats and excretes – as regrettable an example of economy of design as ever was."

– JEFFREY KLUGER

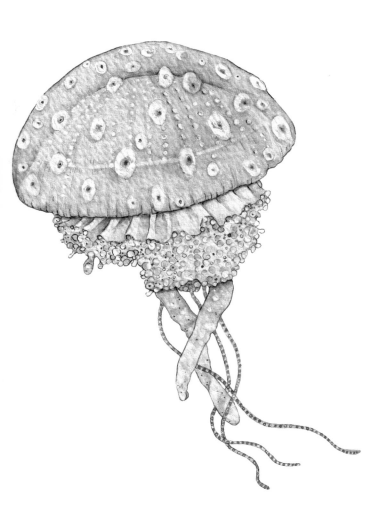

"*By nature, I keep moving, man. My theory is, be the shark. You've just got to keep moving. You can't stop.*"

– BRAD PITT

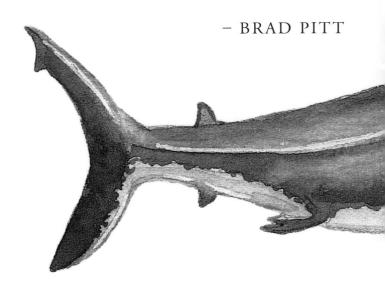

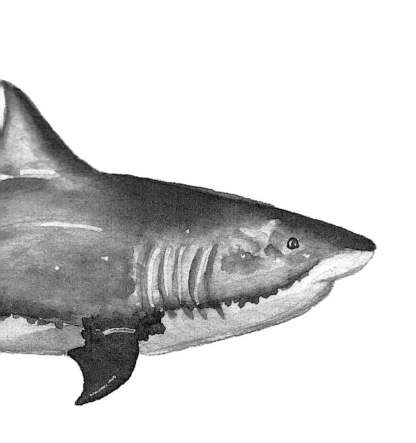

"*Every other mammal that went to sea – seals, sea cows, dolphins – had to evolve for aeons to develop specialised organs and a hydrodynamic body.*"

– YUVAL NOAH HARARI

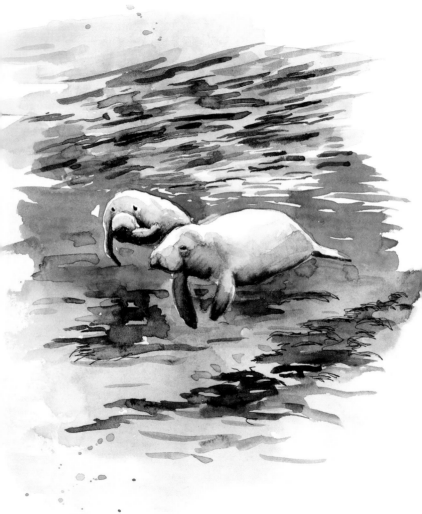

"A penguin cannot become a giraffe, so just be the best penguin you can be."

– GARY VAYNERCHUK

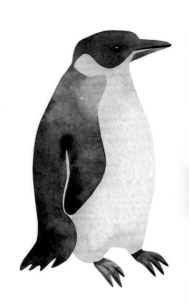

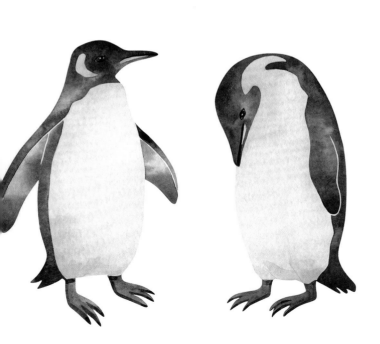

"I see myself as an intelligent, sensitive human, with the soul of a clown which forces me to blow it at the most important moments."

– JIM MORRISON

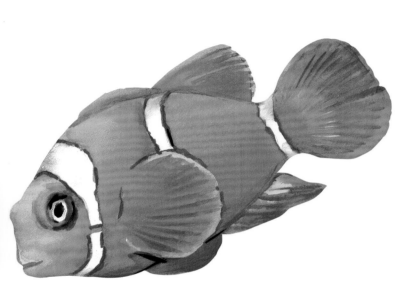

"To go out with the setting sun on an empty beach is to truly embrace your solitude."

– JEANNE MOREAU

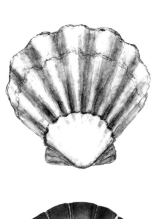

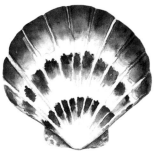

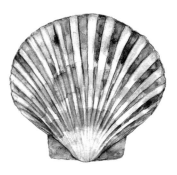

*"How inappropriate
to call this planet
Earth when it is
quite clearly Ocean."*

– ARTHUR C. CLARKE

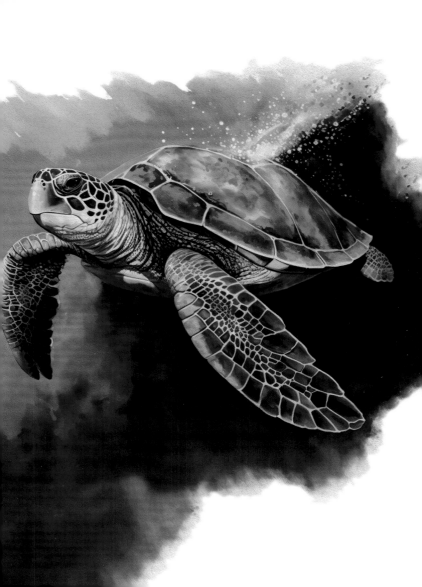

"Seeing that a pilot steers the ship in which we sail, who will never allow us to perish even in the midst of shipwrecks, there is no reason why our minds should be overwhelmed with fear and overcome with weariness."

– JOHN CALVIN

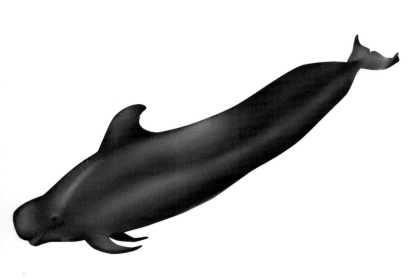

"*The lion and the calf shall lie down together but the calf won't get much sleep.*"

– WOODY ALLEN

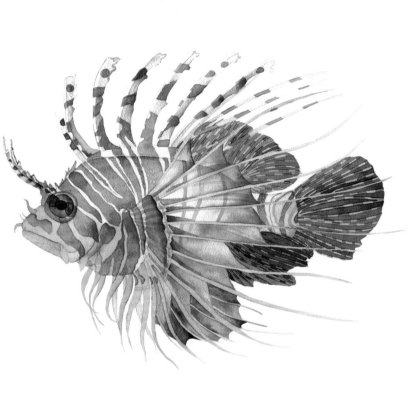

"Hermits have
no peer pressure."

– STEVEN WRIGHT

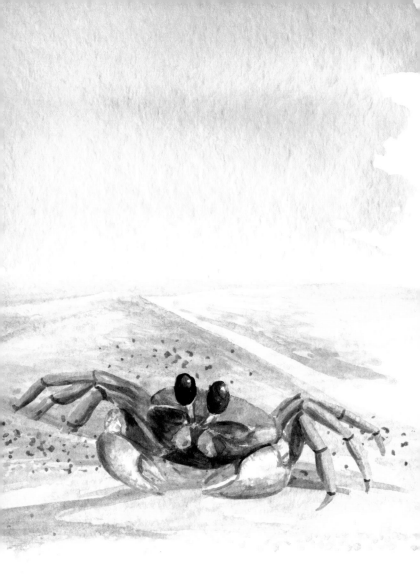

*"Fishing is boring,
unless you catch
an actual fish,
and then it is disgusting."*

– DAVE BARRY

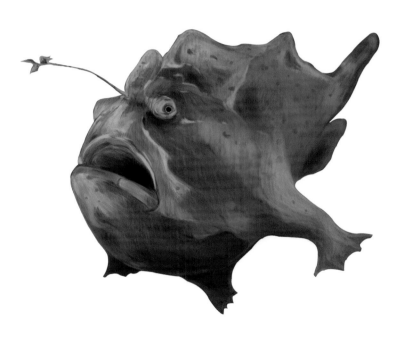

"*Like a starfish, the heart endures its amputation.*"

– GAIL CALDWELL

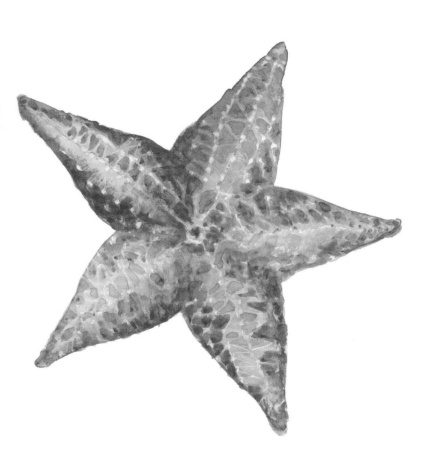

"This magnificent butterfly finds a little heap of dirt and sits still on it; but man will never on his heap of mud keep still."

– JOSEPH CONRAD

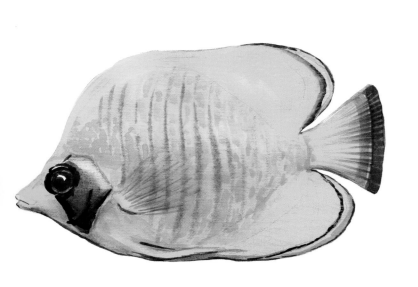

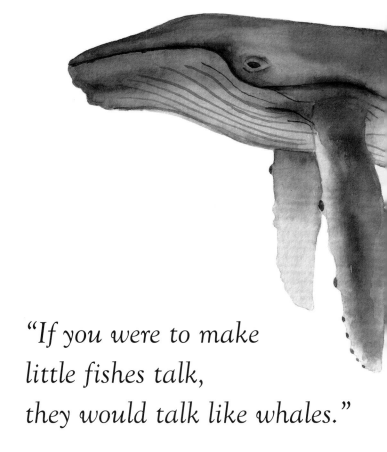

"*If you were to make little fishes talk, they would talk like whales.*"

– OLIVER GOLDSMITH

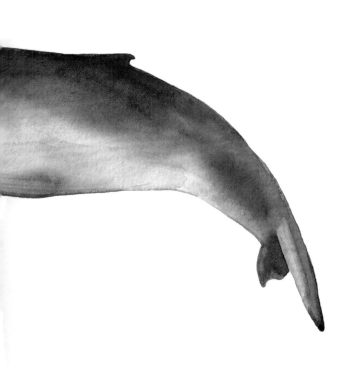

"Marriage is like putting your hand into a bag of snakes in the hope of pulling out an eel."

– LEONARDO DA VINCI

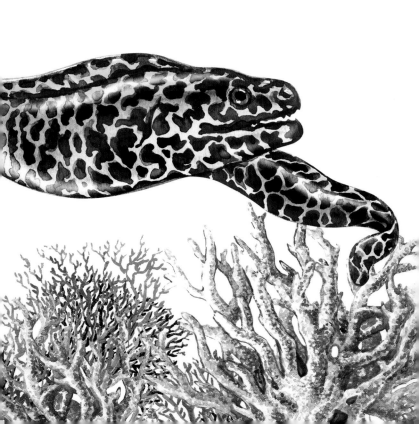

"*Talent without discipline is like an octopus on roller skates. There's plenty of movement, but you never know if it's going to be forward, backwards, or sideways.*"

– H. JACKSON BROWN, JR

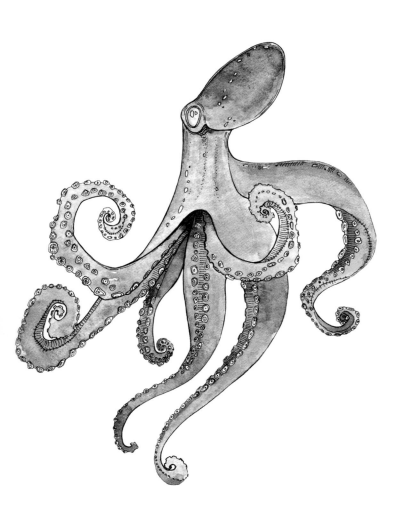

"*Painting, n.: The art of protecting flat surfaces from the weather, and exposing them to the critic.*"

– AMBROSE BIERCE

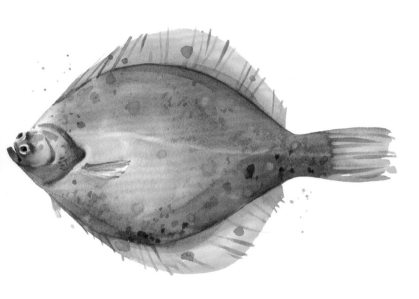

"*Flying is learning how to throw yourself at the ground and miss.*"

– DOUGLAS ADAMS

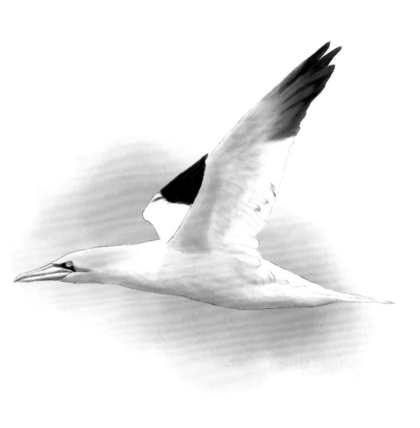

"It does not do to leave
a live dragon out of
your calculations,
if you live near him."

– J. R. R. TOLKIEN

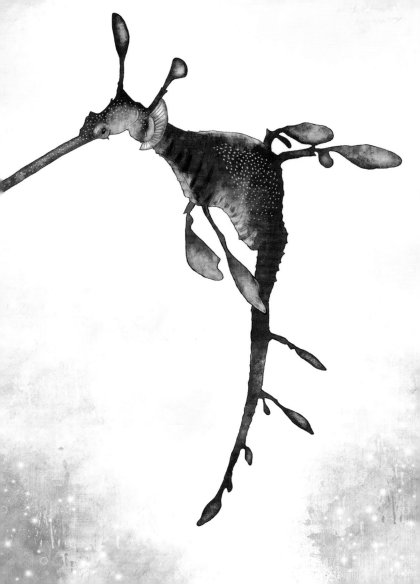

"*The world cannot live without the Arctic; it affects every living thing on Earth and acts as a virtual thermostat, reflecting sunlight and cooling the planet.*"

– PHILIPPE COUSTEAU, JR

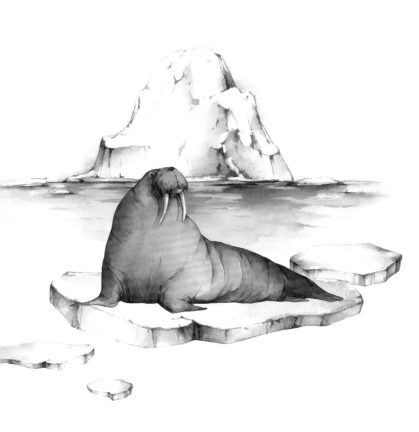

"Ice ages have come and gone. Coral reefs have persisted."

– SYLVIA EARLE

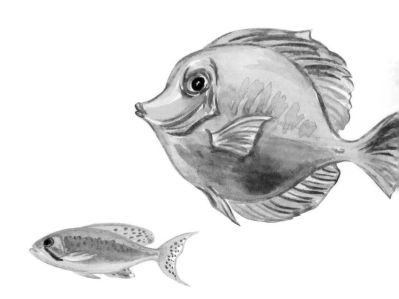

"*I pick my favourite quotations and store them in my mind as ready armour, offensive or defensive, amid the struggle of this turbulent existence.*"

– ROBERT BURNS

*"A baby is born with
a need to be loved —
and never outgrows it."*

– FRANK A. CLARK

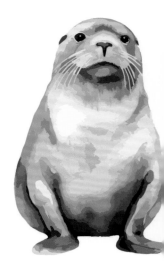

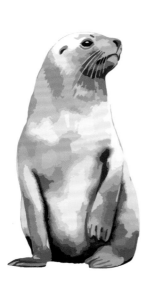
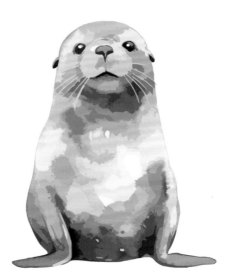

"A house is not a home
unless it contains
food and fire for the mind
as well as the body."

– BENJAMIN FRANKLIN

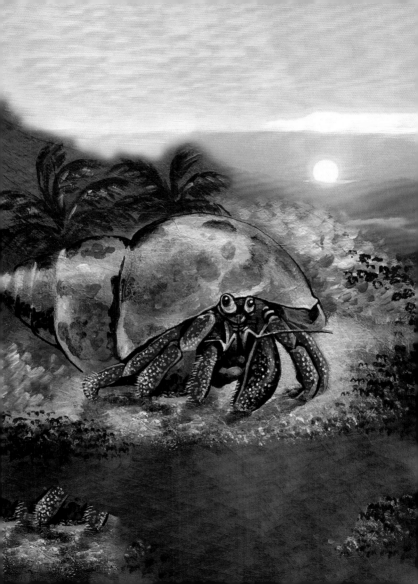

"If the carbon tax really was about saving the world, we would presume the largest industrial emitters of carbon would have to pay it."

– PIERRE POILIEVRE

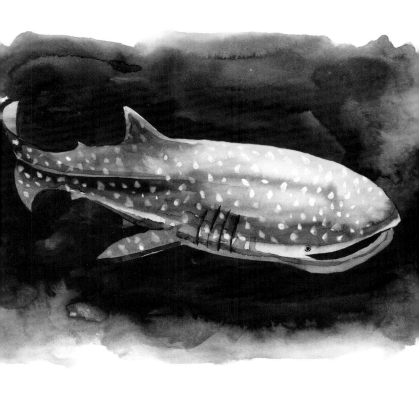

"We ourselves feel that what
we are doing is just a drop
in the ocean. But the ocean
would be less because of
that missing drop."

– MOTHER TERESA

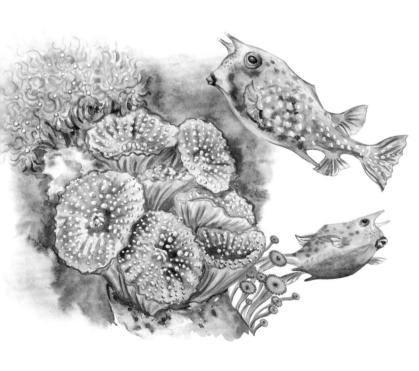

"The happiness of the bee and the dolphin is to exist. For man it is to know that and to wonder at it."

– JACQUES YVES COUSTEAU

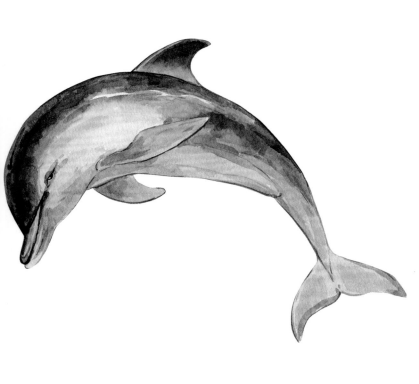

"A beach is not only
a sweep of sand,
but shells of sea creatures,
the sea glass, the seaweed,
the incongruous objects
washed up by the ocean."

– HENRY GRUNWALD

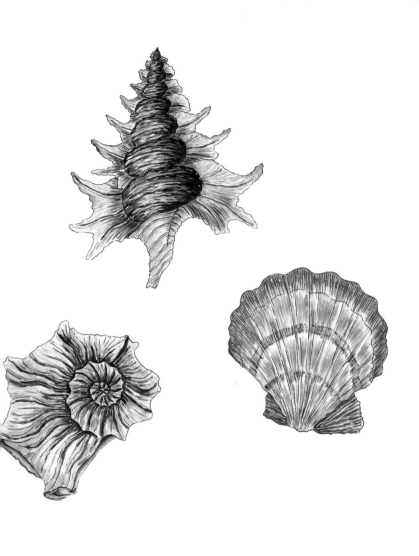

"Living at risk is jumping off the cliff and building your wings on the way down."

– RAY BRADBURY

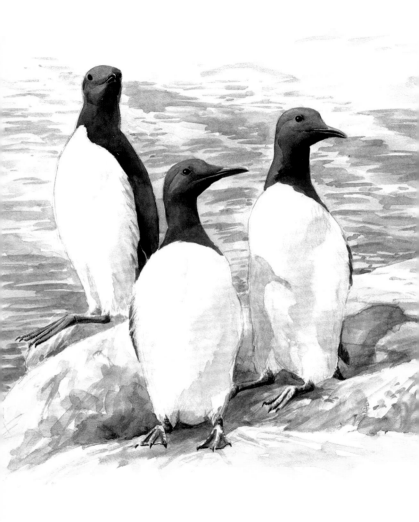

"In spite of her
superficial independence,
her fundamental need
was to cling.
All her life was an attempt to
disprove it; and so proved it.
She was like a sea anemone
had only to be touched
once to adhere to what
touched her."

– JOHN FOWLES

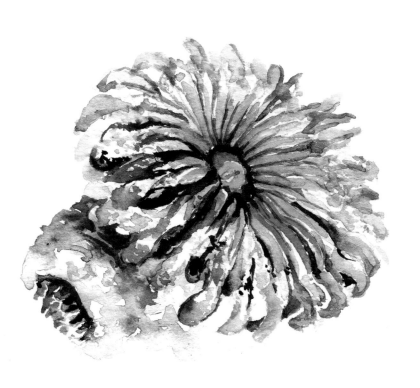

"*Red is the ultimate cure for sadness.*"

– BILL BLASS

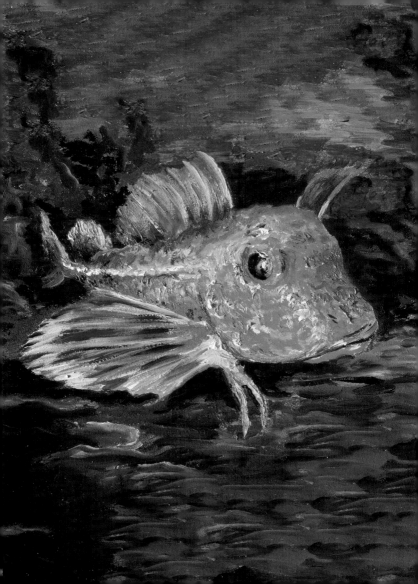

Published in 2024 by Reed New Holland Publishers

Sydney

Level 1, 178 Fox Valley Road, Wahroonga, NSW 2076, Australia

newhollandpublishers.com

A record of this book is held at the National Library of Australia.

ISBN 978 1 92107 371 7

Managing Director: Fiona Schultz
Publisher and Project Editor: Simon Papps
Designer: Andrew Davies
Production Director: Arlene Gippert

Printed in China

10 9 8 7 6 5 4 3 2 1

OTHER TITLES BY REED NEW HOLLAND INCLUDE:

Australian Marine Parks
Graham Edgar, Rick Stuart-Smith and Antonia Cooper
ISBN 978 1 92554 686 6

Chris Humfrey's Incredible Coastal Critters
Chris Humfrey
ISBN 978 1 76079 446 0

Diving With Sharks
Nigel Marsh and Andy Murch
ISBN 978 1 92554 696 5

Top 100 Hot-spots for Sea Fishes in Australia
Nigel Marsh
ISBN 978 1 92107 318 2

Underwater Australia
Nigel Marsh
ISBN 978 1 92151 792 1

For details of these books and hundreds of other Natural History titles see
newhollandpublishers.com and follow ReedNewHolland and
NewHollandPublishers on Facebook

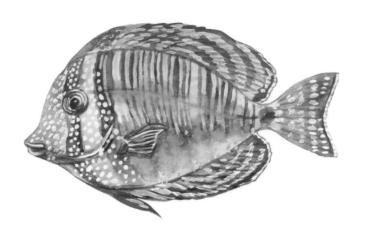

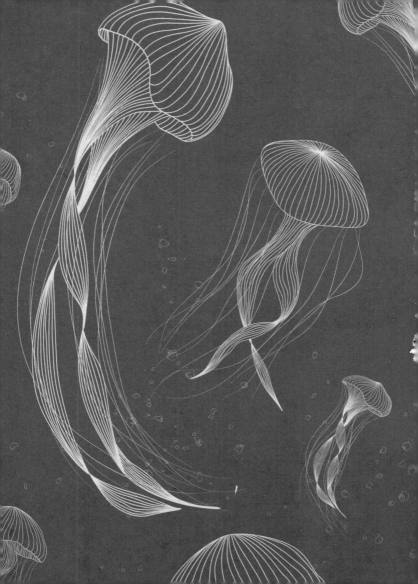